Just Sit

Micheline Montgomery
Kaja Montgomery *editor*

Copyright © 2016 Micheline Montgomery
All rights reserved.
ISBN-13: 978-1534919235
ISBN-10: 1534919236

Table of Contents

Introduction ... 7

Quiet Escapes .. 10

Luminosity ... 12

Bridge of Light ... 14

Love is, Has Been and Will Be. Path 16

It Happens in the Heart ... 18

Sacred .. 20

Beyond ... 22

"You can't know it, you can only be it." 24

A Beacon of Hope .. 26

Create Your Inner Outer Sanctuary 28

Grace .. 30

The Awakened Heart ... 32

"Peace comes from within. Do not seek it without." ..34

Buddha..34

Renewal. Just Sit..36

Micheline on Micheline38

Kaja on Kaja ...40

Introduction

We live in an era, especially in large cities, where rush becomes the norm. We hurry to wake up, to get the kids to school, to prepare lunches. We even hurry on our breaks and maybe use this time to go to the gym. Then we arrive home worn out, having first stopped to grab a quart of milk.

This artist book is composed of 14 mixed media images mostly of the Buddha. For me, the act of creating Buddha paintings represents a symbol of peace. When I am at my art table and facing a blank canvas, I often catch myself painting a Buddha image. Without meaning to, it seems I have created yet another Buddha. "So be it," I say to myself, "I am a Buddha lover!"

I never tire of admiring Buddhas. Whether they are in museums, galleries, magazines, people's houses or my own. They envelop me with a beautiful feeling of serenity. I wonder, "How does he do it?" and "How can I do it?"

I collect Buddhas. One is not enough. If by chance peace has left me (it does happen), I walk through my home and studio. Surrounded

by Buddhas, magically equanimity begins to return.

This book was an opportunity for me to distill and express with art and words what can happen when you attempt to live with peace in your heart. From my own journey, I offer what has helped me to find peace. Just sit and enjoy what happens to you. Listen to the voice of silence. Allow things to be passed from heart to heart without words. And most importantly, take time to laugh.

> The voice
> Of a wayside flower,
> Doesn't attract a busy mind.
>
> Richard Kirsten Daiensai

Quiet Escapes

A quiet escape is a place where we break free from outer constraints and learn to regain inner freedom and serenity. It is important to find that special place in our lives. It can be simpler than you think. It can be as easy as making art, going for a walk or admiring a blossomed magnolia tree.

However, we need to remember that finding a place to escape the chaos without, will not necessarily free the chaos within. With consistent efforts we will discover the joy within. Slowly we will see chaos, sorrow and pain dissolve.

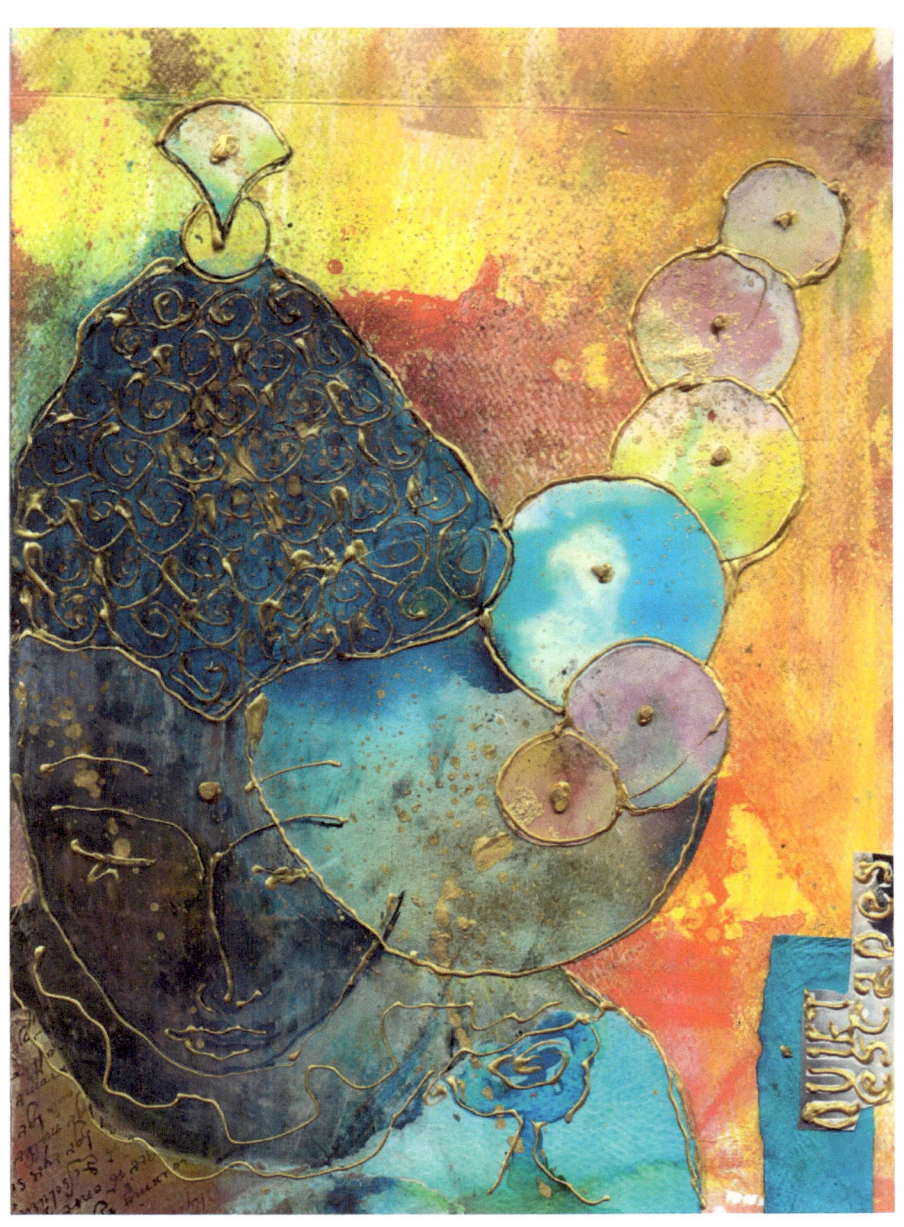

Luminosity

Luminosity is an intrinsic brightness. When we are in a peaceful state, we radiate warmth. It is as if we project an aura of light which attracts others to us and brings positivity into our lives.

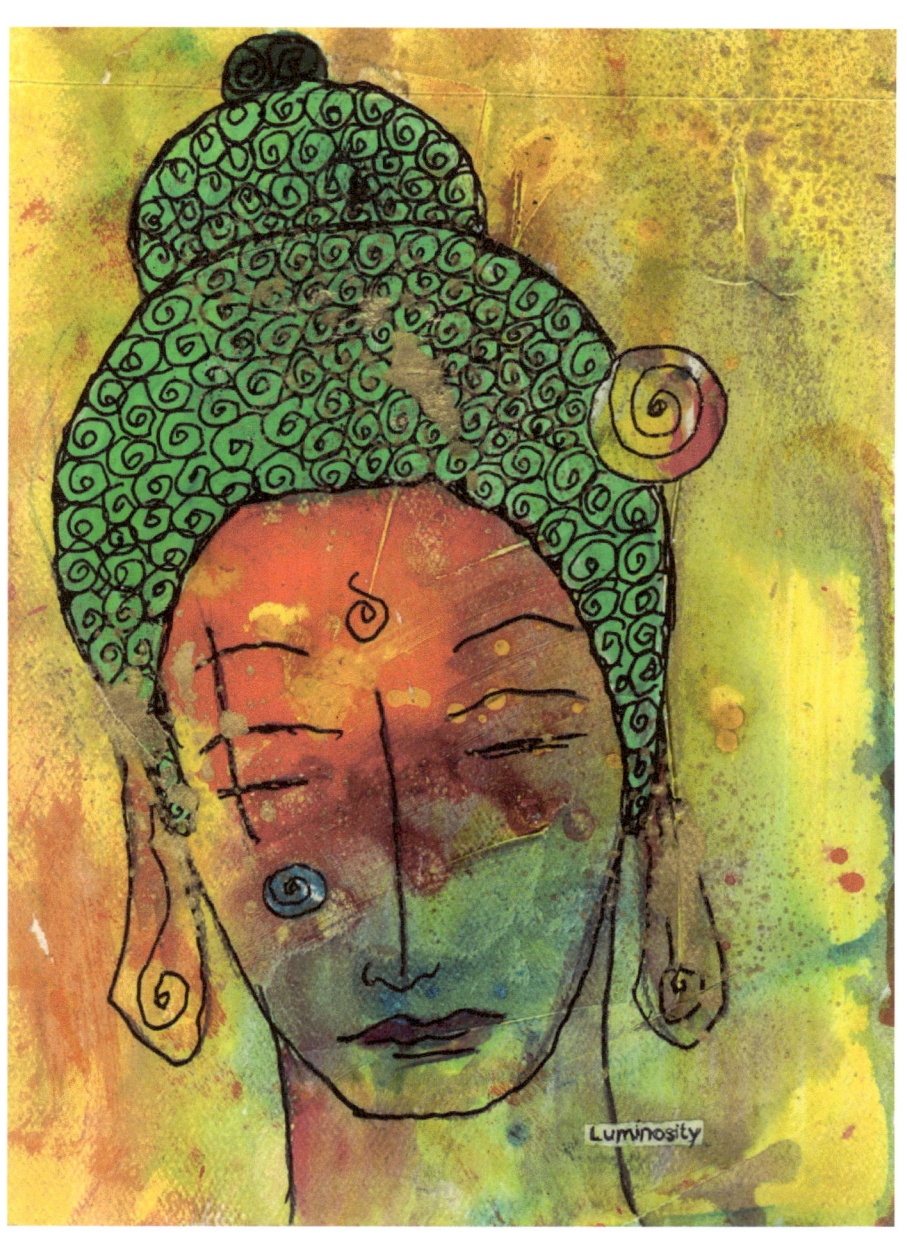

Bridge of Light

Communication between souls is mostly wordless. When two people immediately make a connection, you will often hear them say "I cannot explain it. I just felt it. I just knew." This is what I call the Bridge of Light. The Bridge of Light links people of like mind and soul. This bridge will sometimes make itself present in times of need. In this way help may come unexpectedly. We just need to be open and grateful.

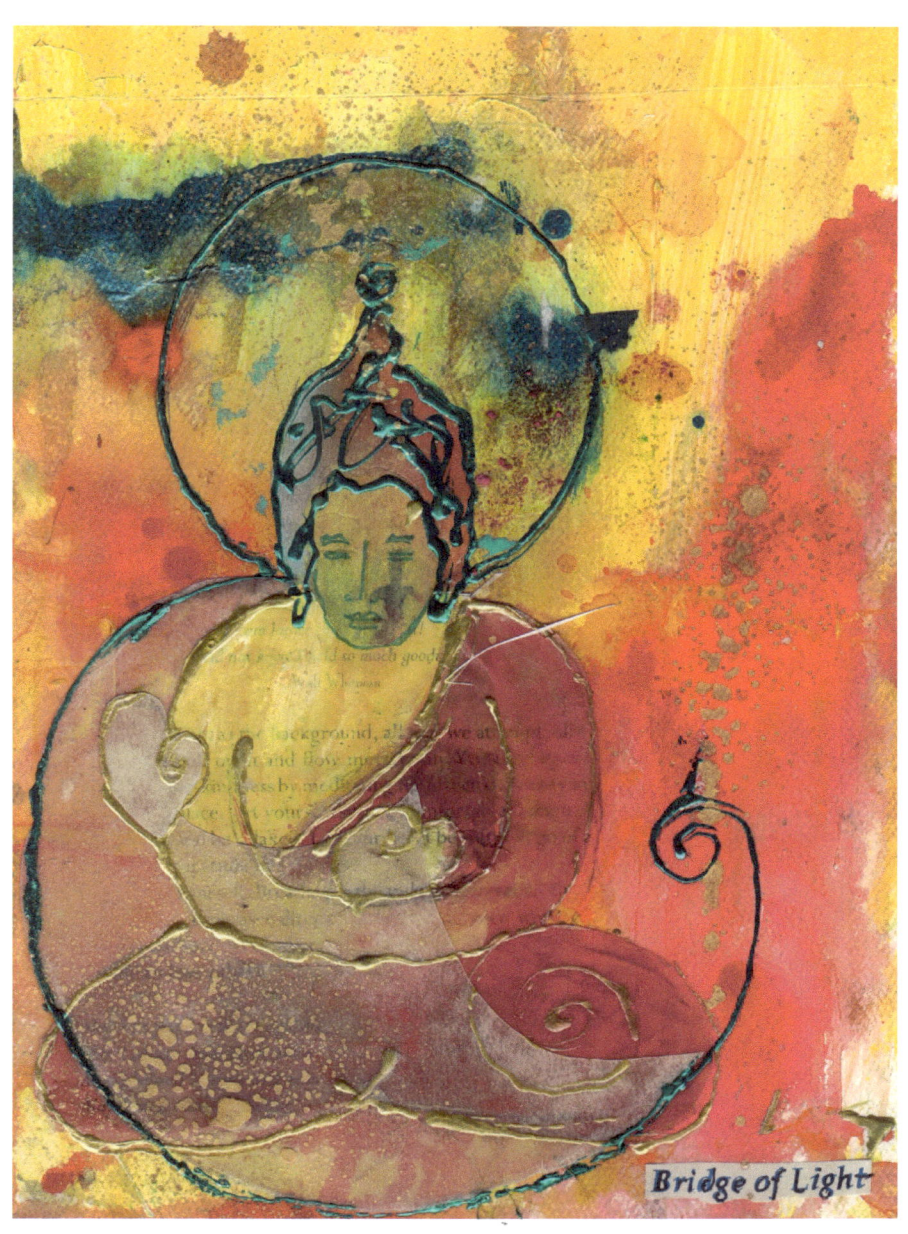

Love is, Has Been and Will Be. Path

We often fail to realize or take for granted the importance that love has in our lives. Love in all its forms is an undercurrent, the driving force that guides and inspires our thoughts and actions.

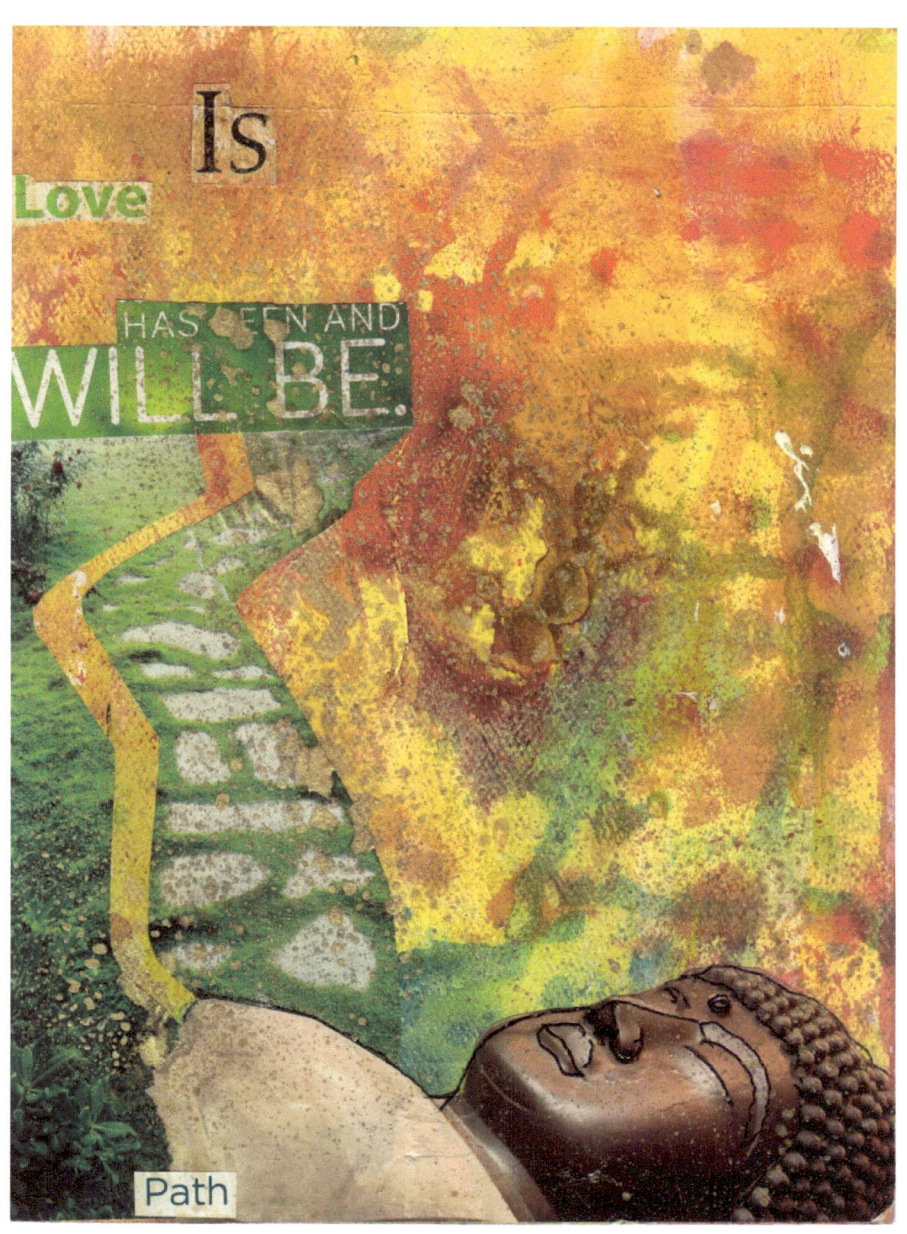

It Happens in the Heart

One cannot have peace of mind without peace of heart. We need to remember to nurture our inside with love, compassion and generosity so that it becomes a haven of comfort for ourselves. And in turn we are then able to share this comfort with others.

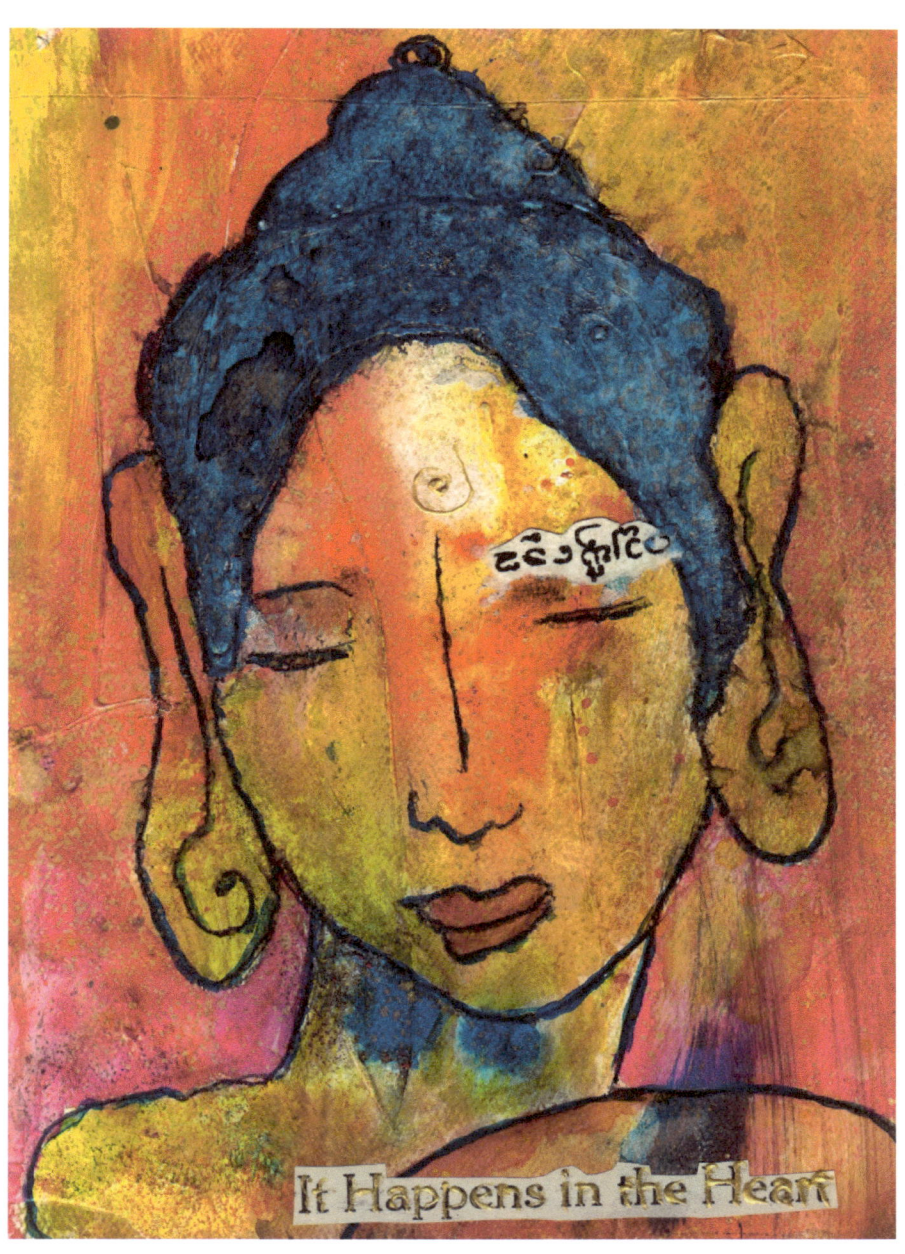

Sacred

a man and a soul

in a desert, a man met a soul
dancing strange sounds of a love song
so beautiful were the silent moans
that in his heart them he wanted to hold
but the soul in her transparent voice uttered
do not take these moans away unless you can
feel them with me
how do I do that
please show me
so it happened that in the middle of the desert
a soul and a man
sat in the silent sand
one teaching while
the other was learning

months and years have passed
and the soul and man
are strangely still sitting in the sand
but now that the man has learned to feel
the dancing sounds of the soul
he is teaching the soul
how to read the thoughts of man

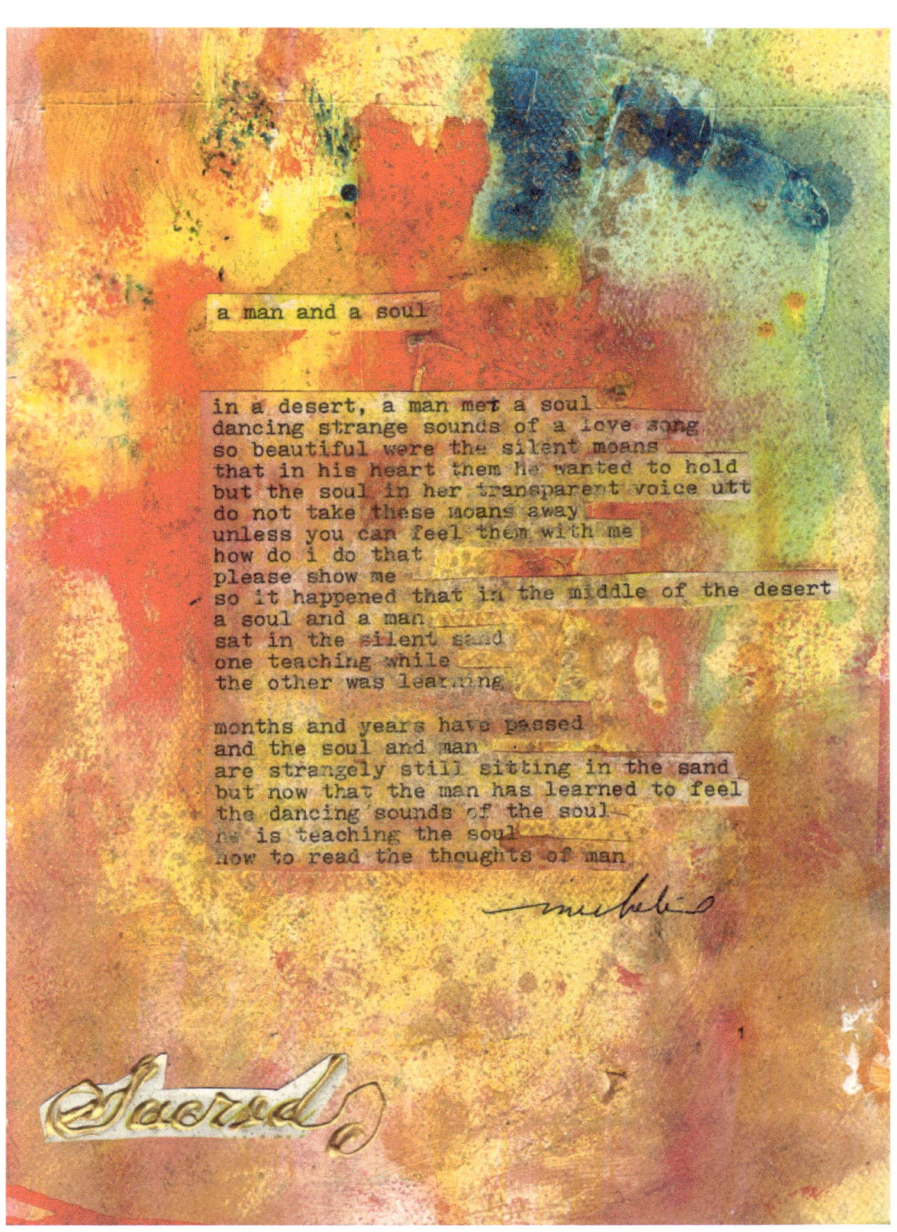

Beyond

It is easier to believe in what we see. However, it would be helpful to spend more time looking beyond the concrete to understand what is important in life. In learning 'to see' we come to the realization that 'seeing' is multilayered. Situations are not always what they seem.

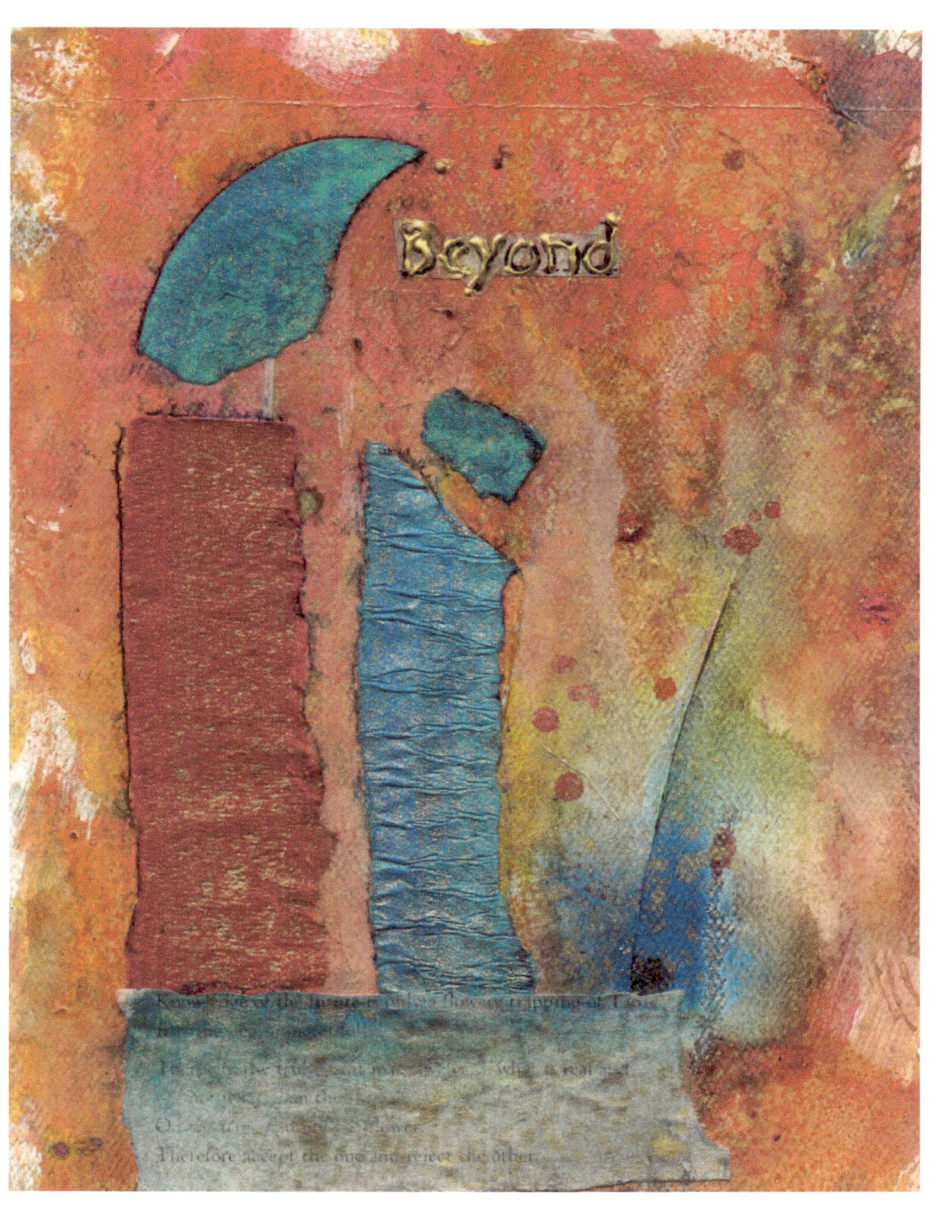

"You can't know it, you can only be it."

Lao Tzu from Tao Te Ching

Many times, we insist in having answers to our questions immediately. Little do we know that when we 'just sit' we develop inner peace and wisdom which leads to knowing. Then answers are no longer needed.

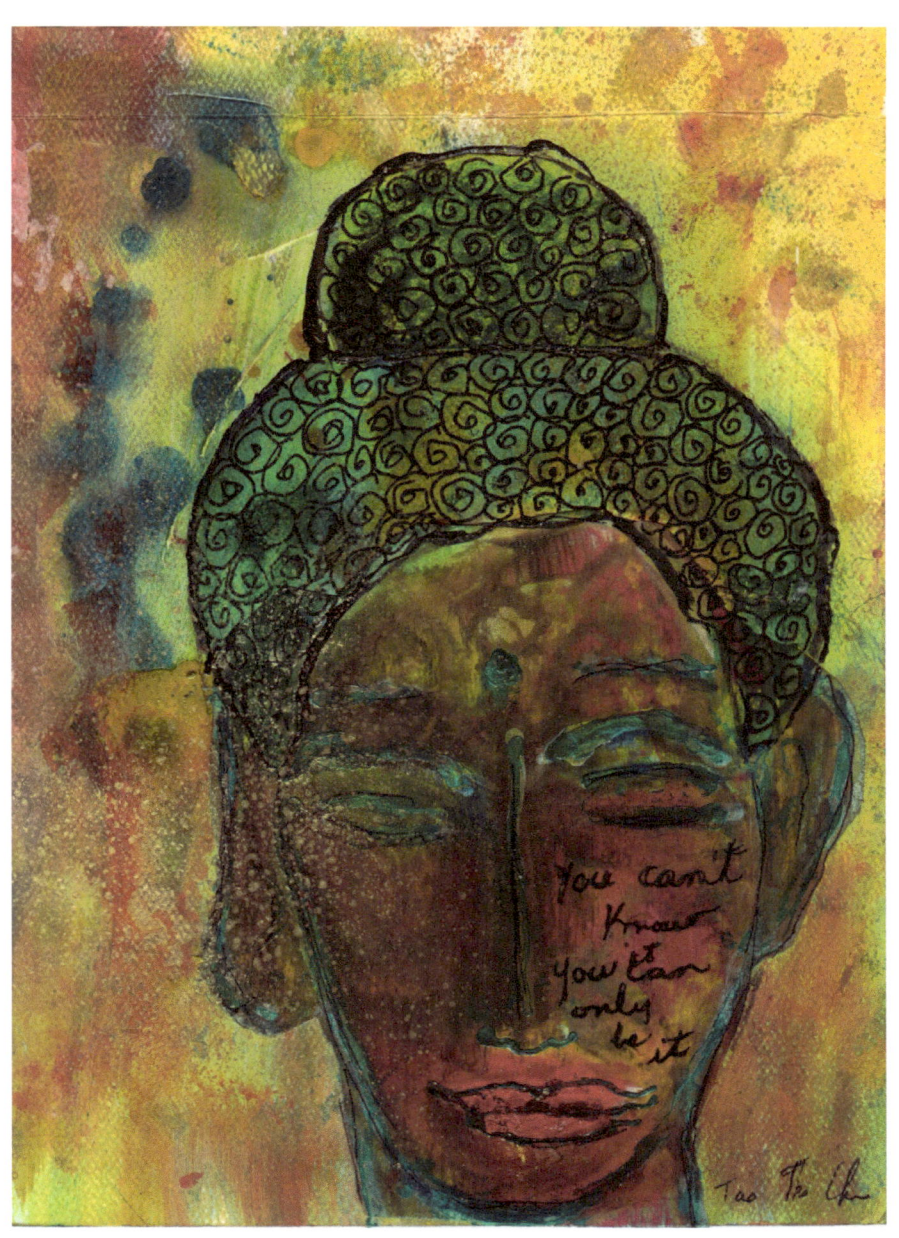

A Beacon of Hope

Let us be a lantern so that we warm the heart of those who are lost, frustrated or wounded. Unknowingly, we become the inspiration to light their own candle.

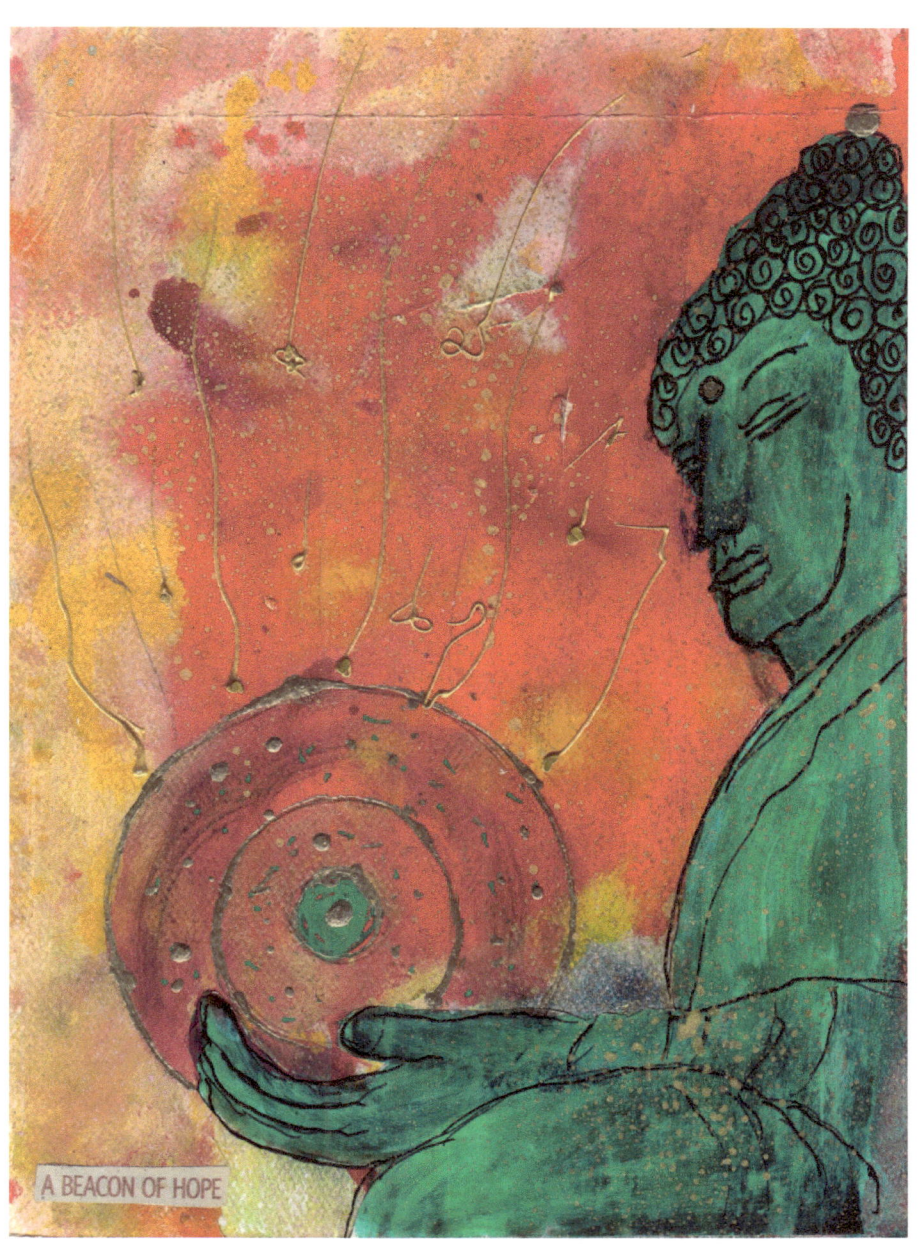

Create Your Inner Outer Sanctuary

A sanctuary is a place of refuge where we feel protected and comforted. We can create such a place in our home to replenish our spirit. It can be as small as a shelf or as large as a room. All that is necessary is for that special area to instill a feeling of serenity and sacredness.

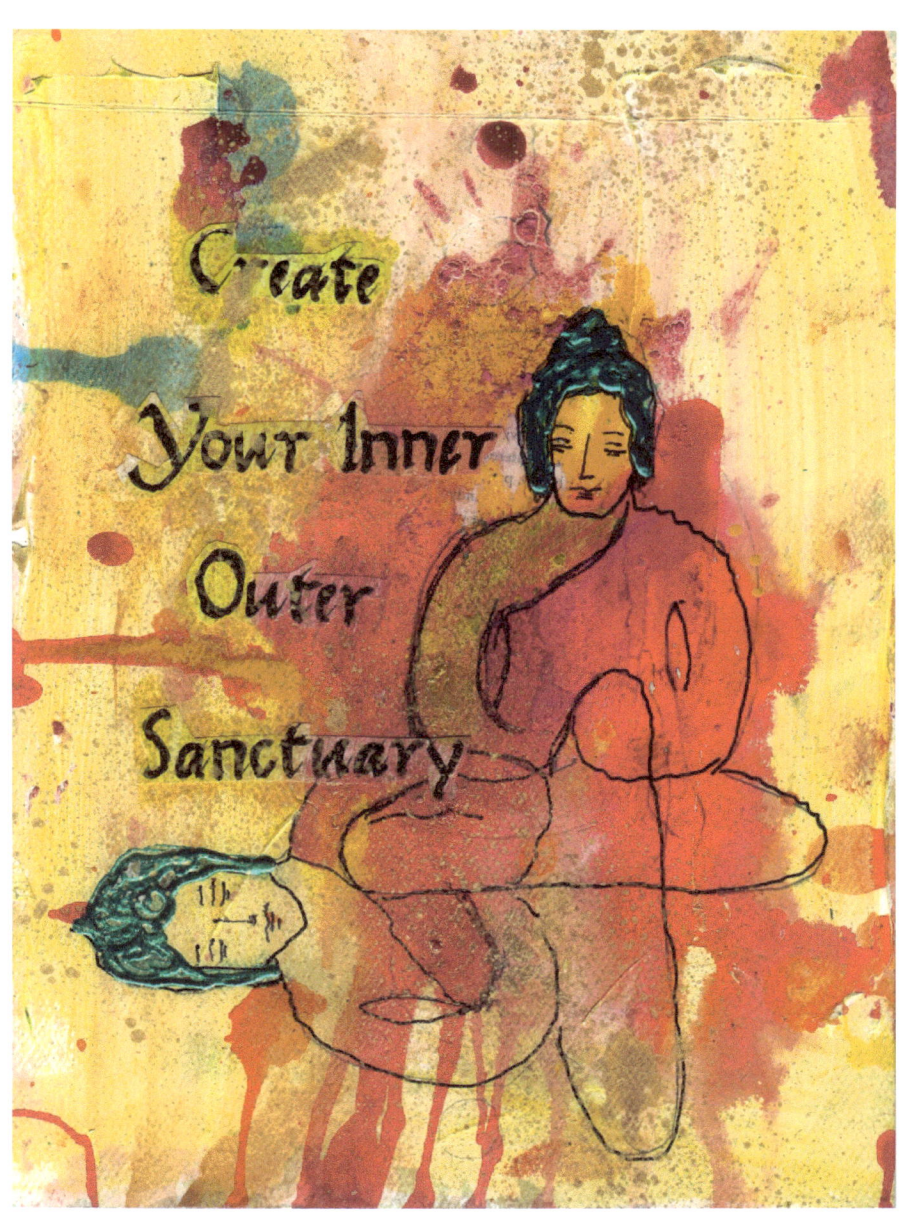

Grace

Grace surrounds us. We often do not recognize it. It comes in many ways, often very small. As we become more aware we will be amazed how blessed our lives are. Through this consciousness we will be better able to express our gratitude by sharing ourselves with others.

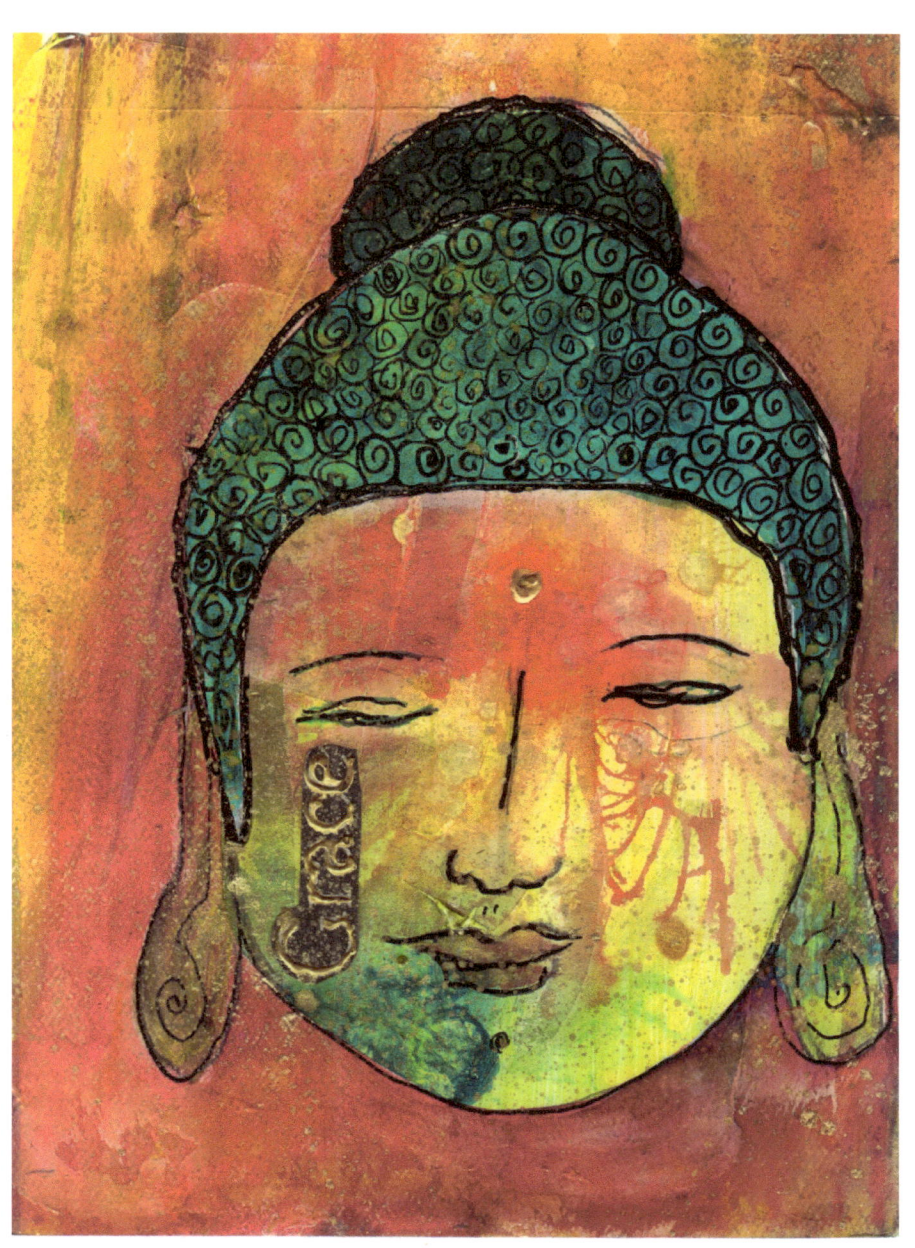

The Awakened Heart

A person with an awakened heart has no need to know why, when and how things happen. He lives in the moment. He lets things and situations unfold from instant to instant with full acceptance and joy in his heart.

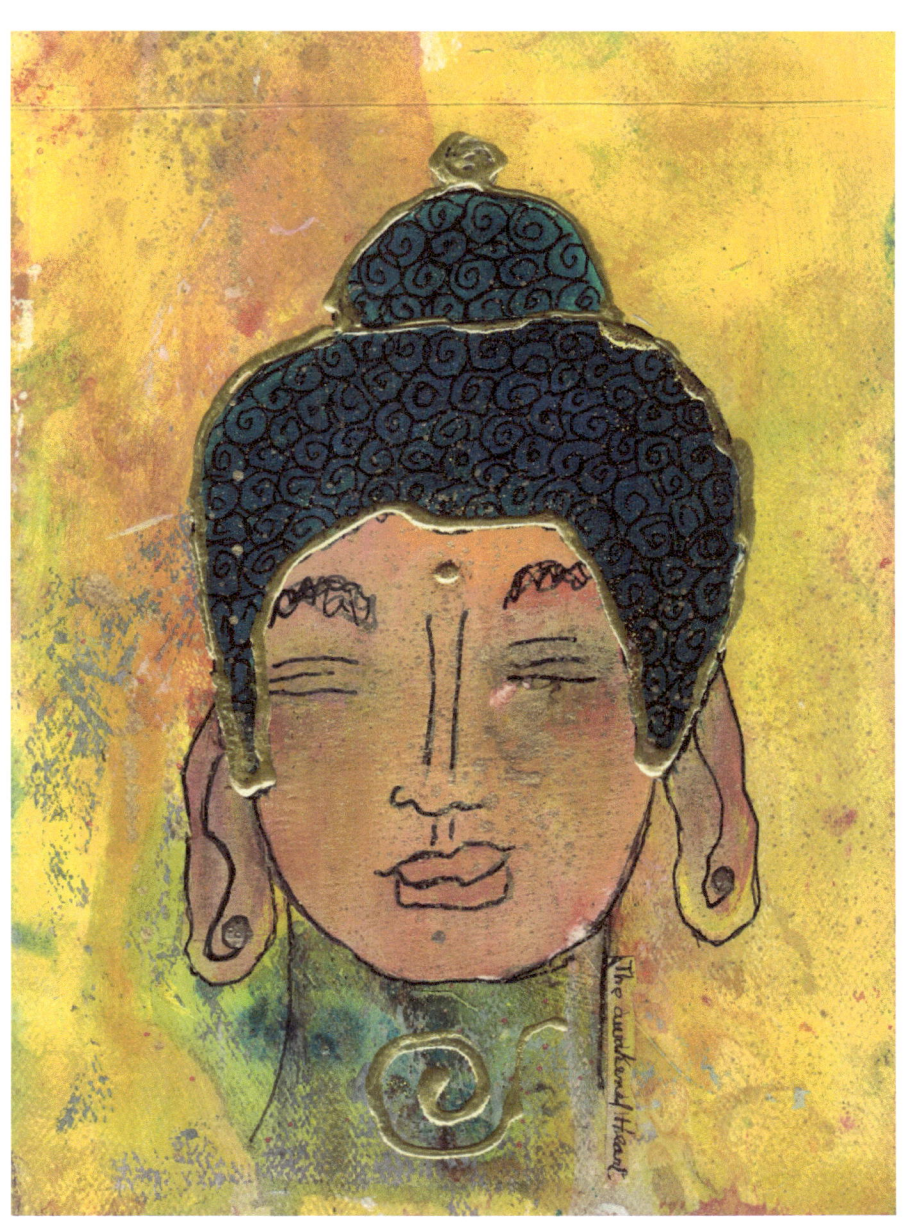

"Peace comes from within. Do not seek it without."
Buddha

The turmoil and chaos of the outside world will not impact us as much if we have found peace within. A calm interior is bound to be less prone to anger and frustrations. We also become better able to appreciate the abundance life bestows upon us and offer it to others.

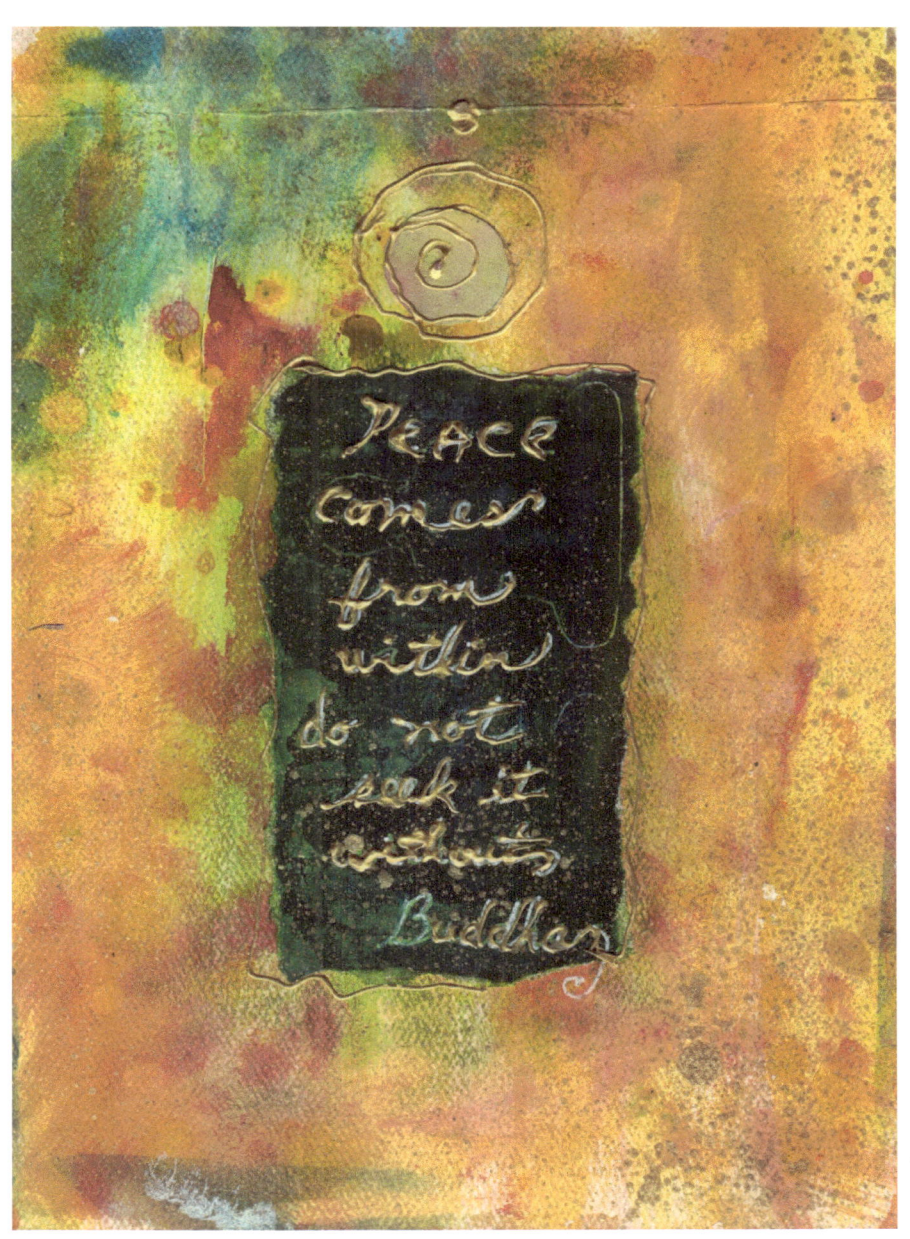

Renewal. Just Sit

When all is said and done and we 'just sit' wherever we are and whenever we can, we fill with energy, compassion and love for ourselves and others. When the mind is quiet, the heart listens.

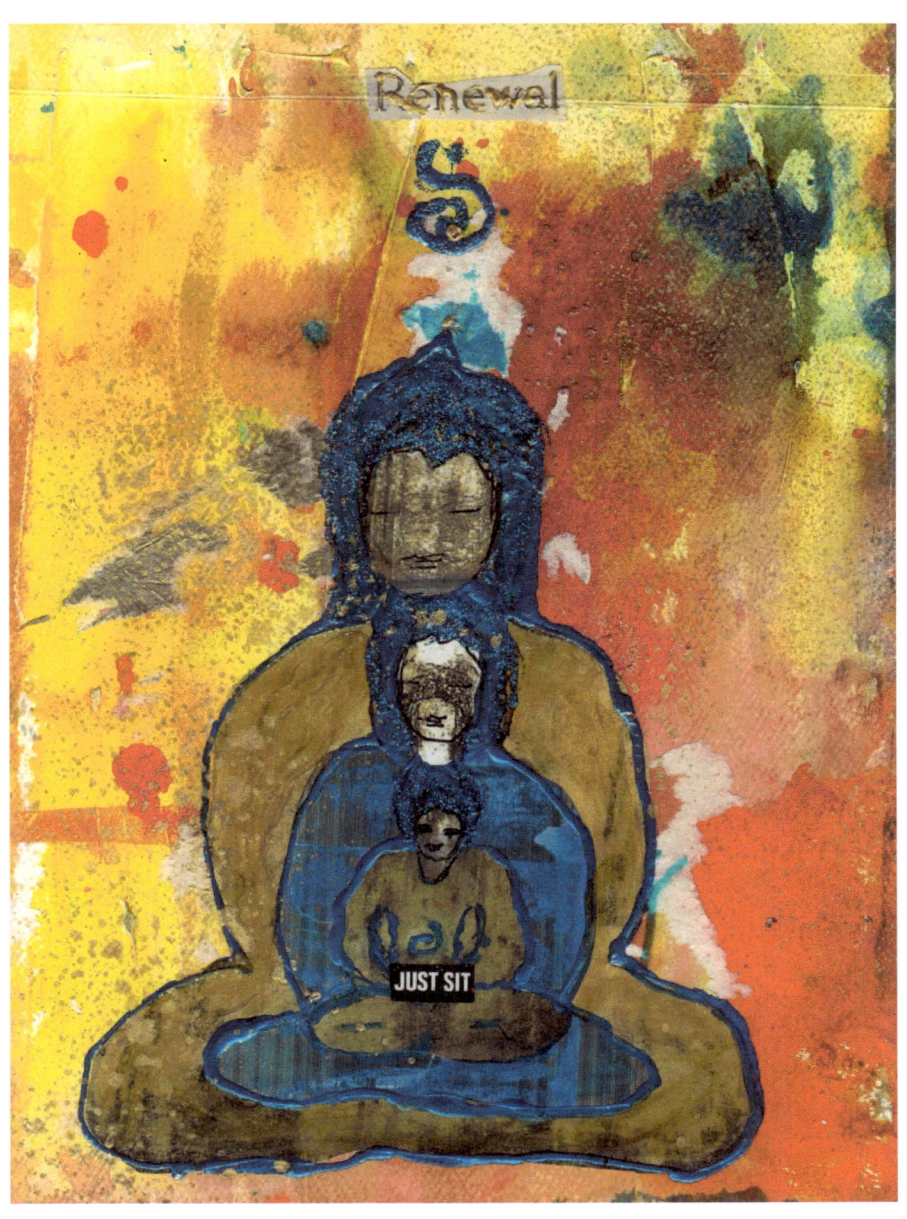

Micheline on Micheline

I have always created. I cannot separate art from life. I paint everywhere and on almost every-thing. I think of art when I wake up and dream of art when asleep. Buddhas, Angels, Nurses, Moms and Children are recurrent themes.

How I embrace life is how I express it through art. What interests me is how we transform the simple ordinary moments, as well as the complexities of life's journey into peaceful, beautiful and meaningful works of art. This endless spiritual quest remains an ever exciting and magical path.

As an artist, I make efforts to choose methods and materials that respect the earth. In my collage, I endeavor to use materials that are found, recycled and re-used, rather than bought. As well, I use water-based paints, acid free glue, cotton rag and stone paper. I am constantly seeking new ways to 'green' my art.

My life as an artist has been enriched by my long experience as a psychiatric nurse and my interest in human behaviour. I have a love of

world travel and reading, especially biographies, art and spiritual books. I have been blessed with 3 children and 6 grandchildren who bring me immeasurable joy.

Kaja on Kaja

My mother and I have been collaborating since I was a child. She has always validated my ideas and helped them come to fruition. So it is with pleasure that I return the favour through designing and editing this book.

I am an artist in my mother's footsteps. My medium is sculpture. When an image surfaces in my mind, I let it guide my hands. As an art piece unfolds before me, it is one of the few times that I am truly living in the moment, completely focused on my task.

I am a full-time teacher of kindergarten children with special needs. I enjoy helping these young souls become successful and start them on the journey of being the best that they can be.

I find peace in being in my backyard and creating a beautiful natural space filled with art. I am also a Flamenco dancer, have a passion for music and mother of 2 amazing boys

Micheline's and Kaja's art can be viewed on their website.

www.pearangelartstudio.ca

Thank you to Stewart, Kaleb and Jojo for taking the time to read and comment. We appreciate your help.

www.ingramcontent.com/pod-product-compliance
Lightning Source LLC
Chambersburg PA
CBHW040930180526
45159CB00002BA/677